This coloring book belongs to _____

ROCKET

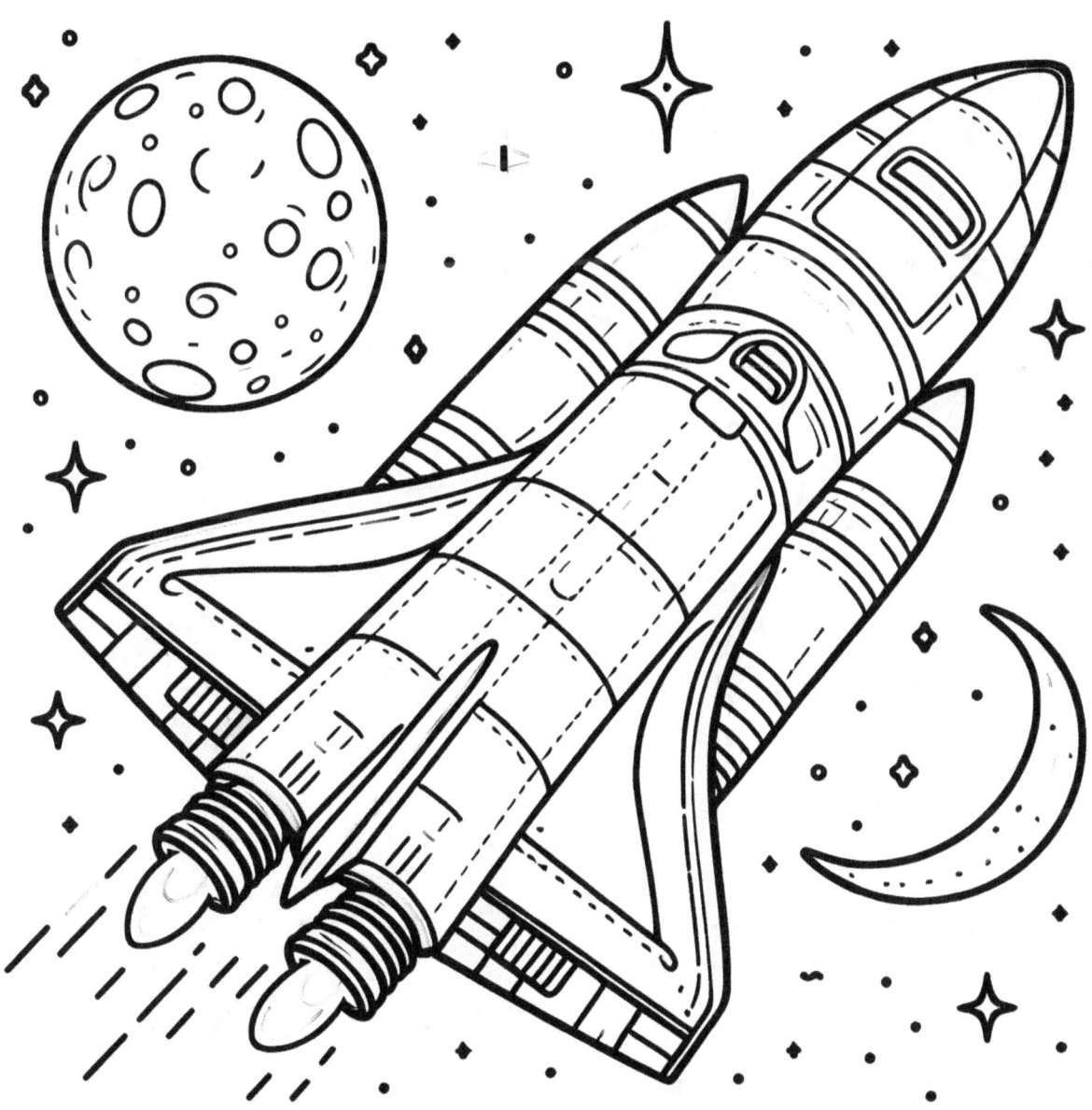

BOAT

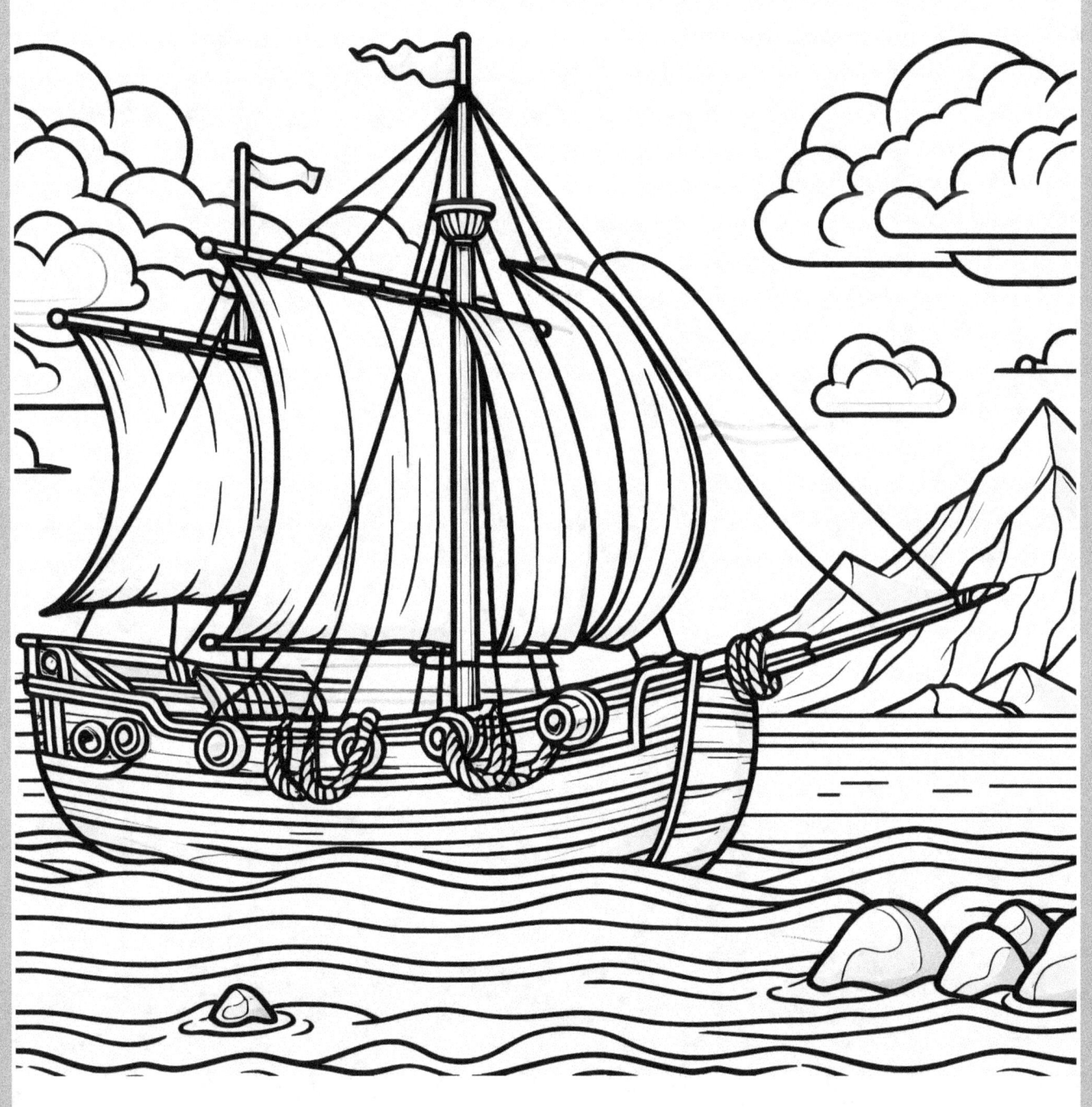

FERRY

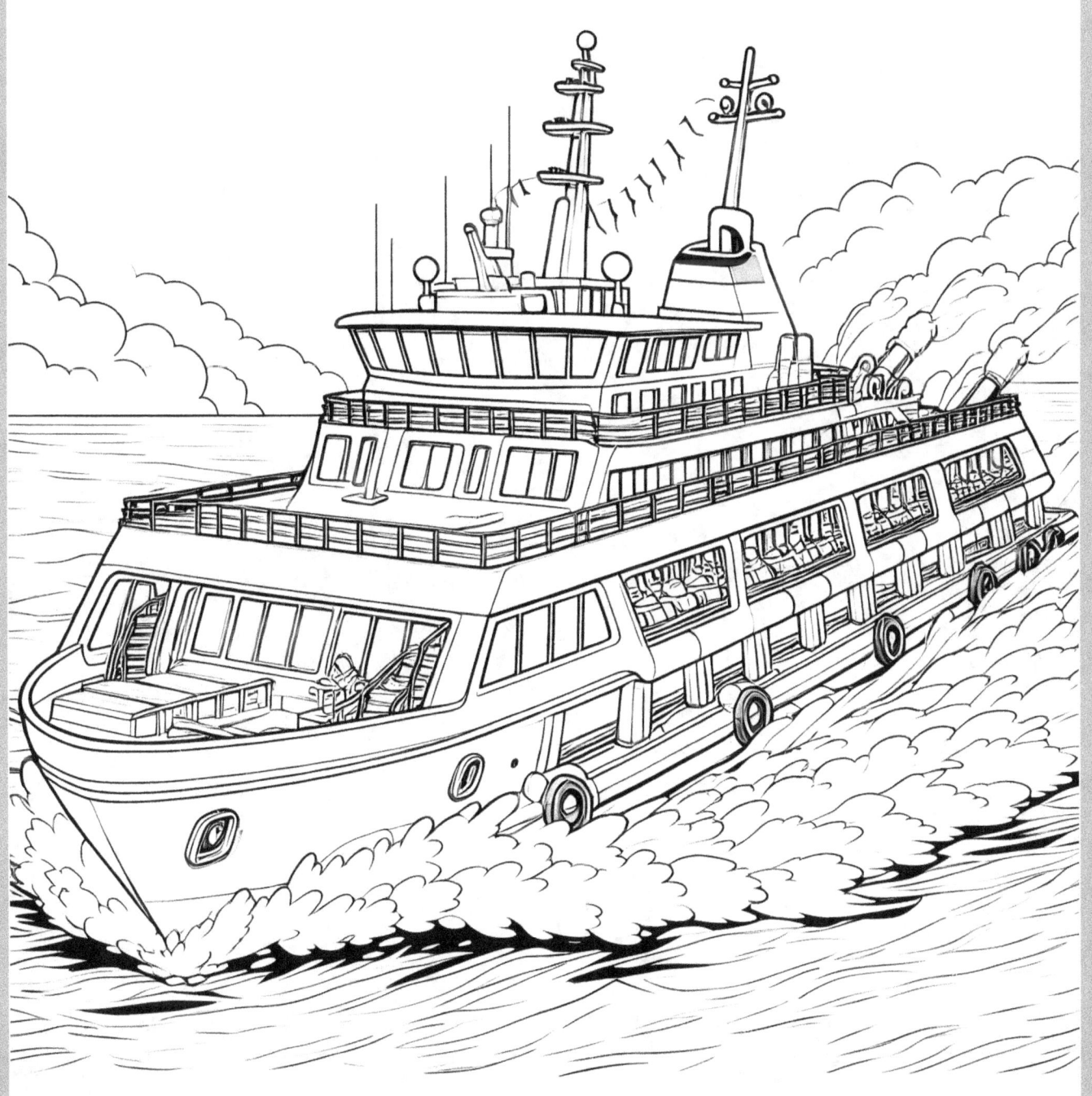

HOT AIR BALLOON

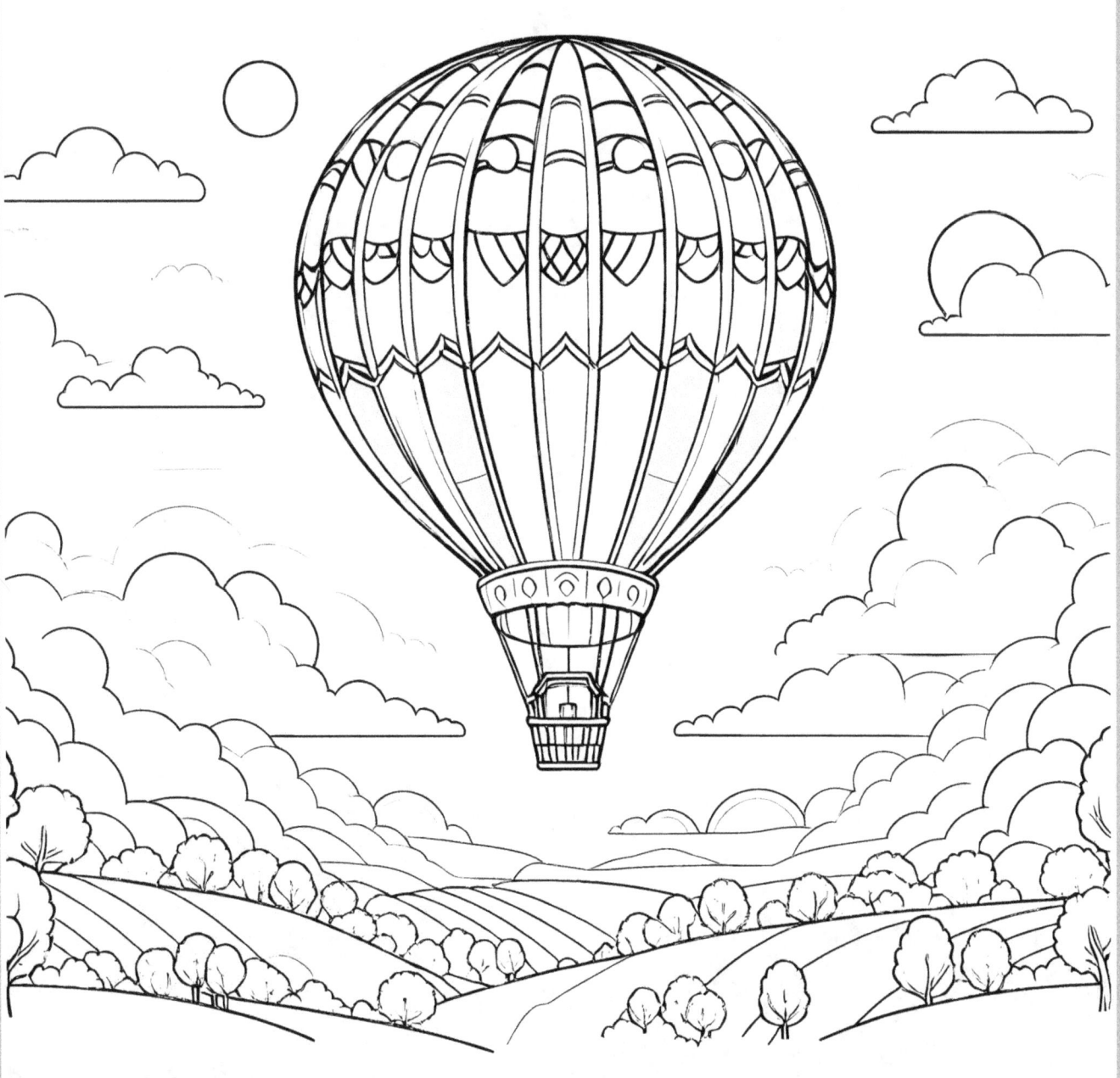

CANOE

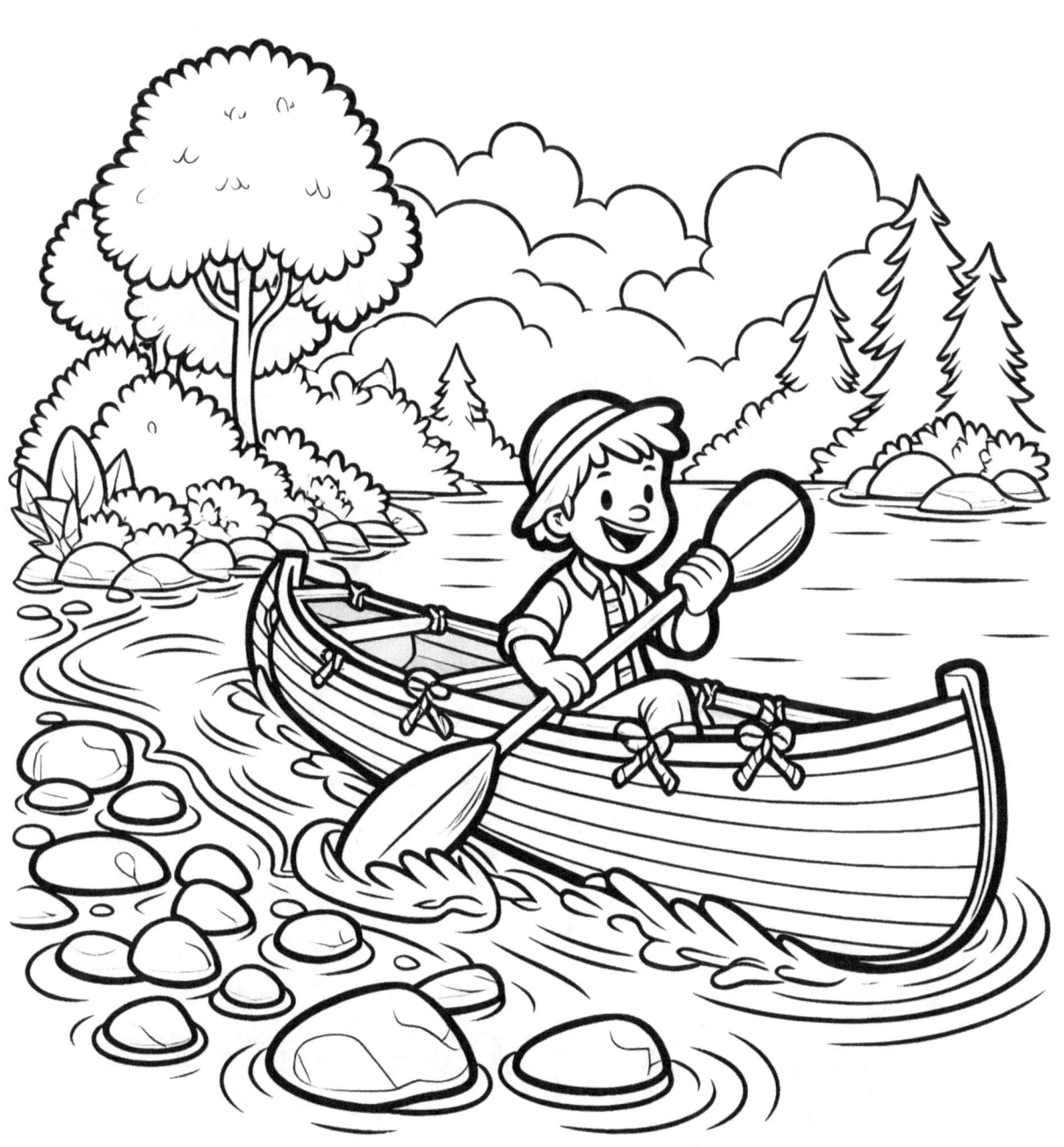

PATROL

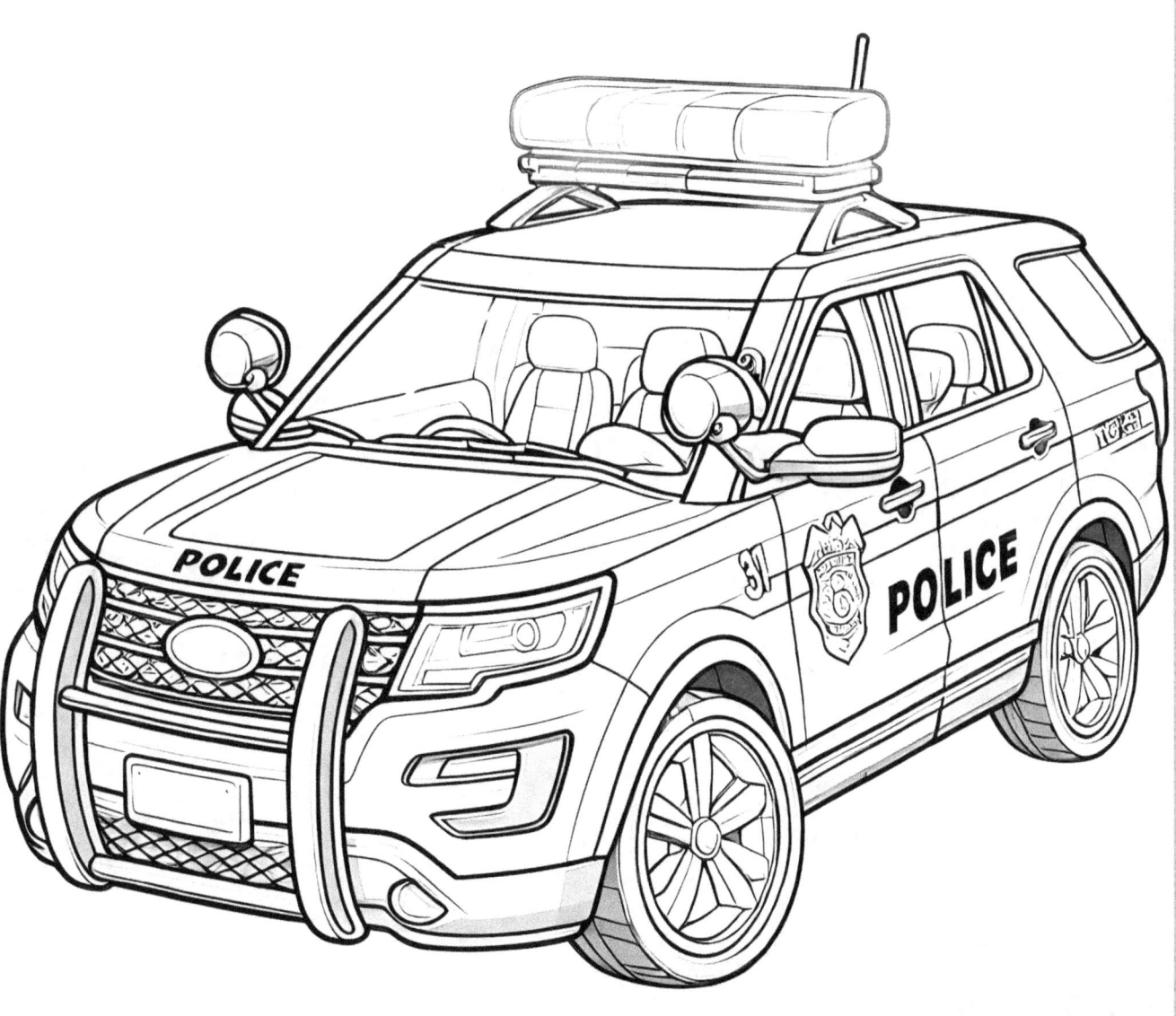

HELICOPTER

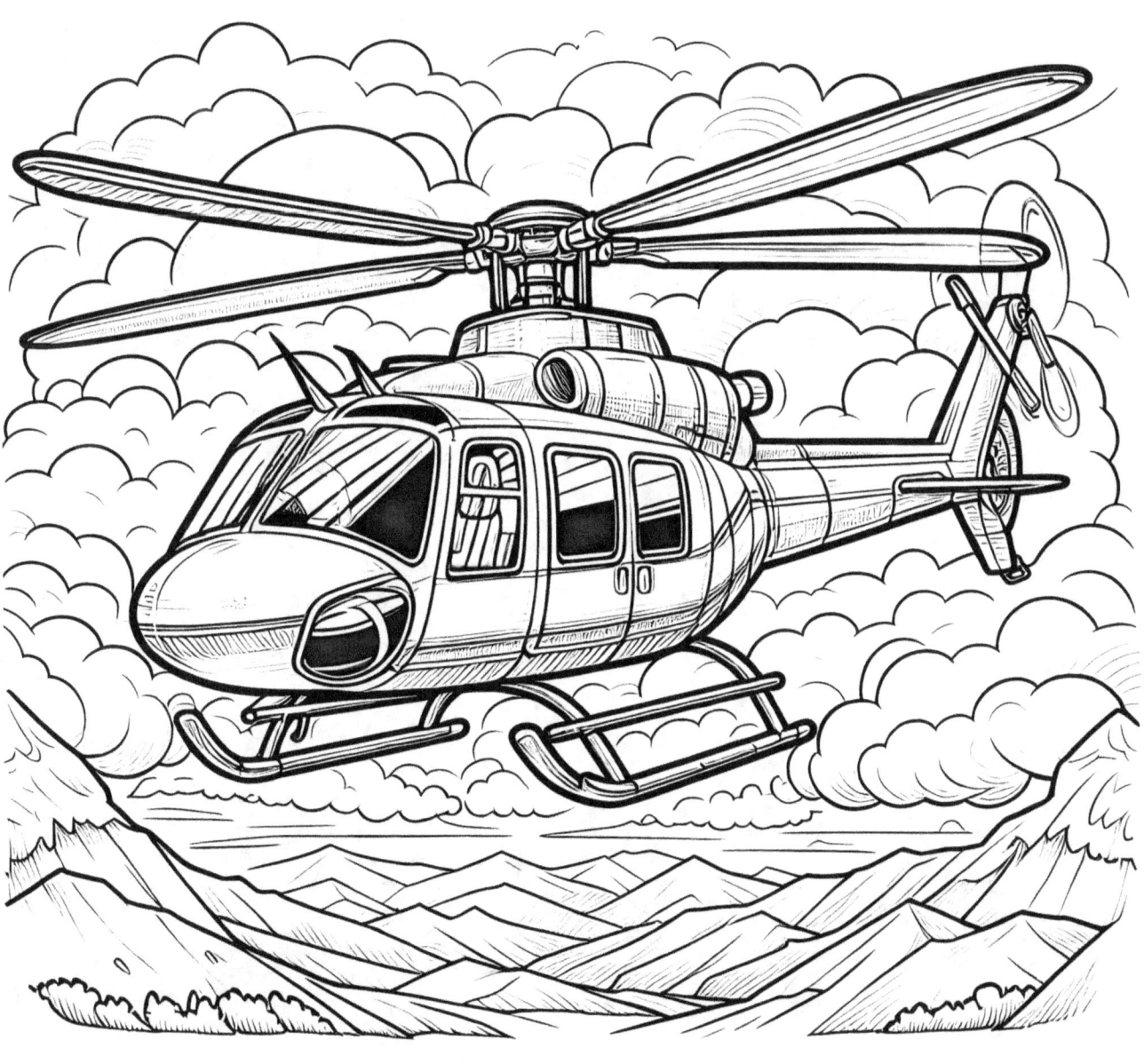

AIRPLANE

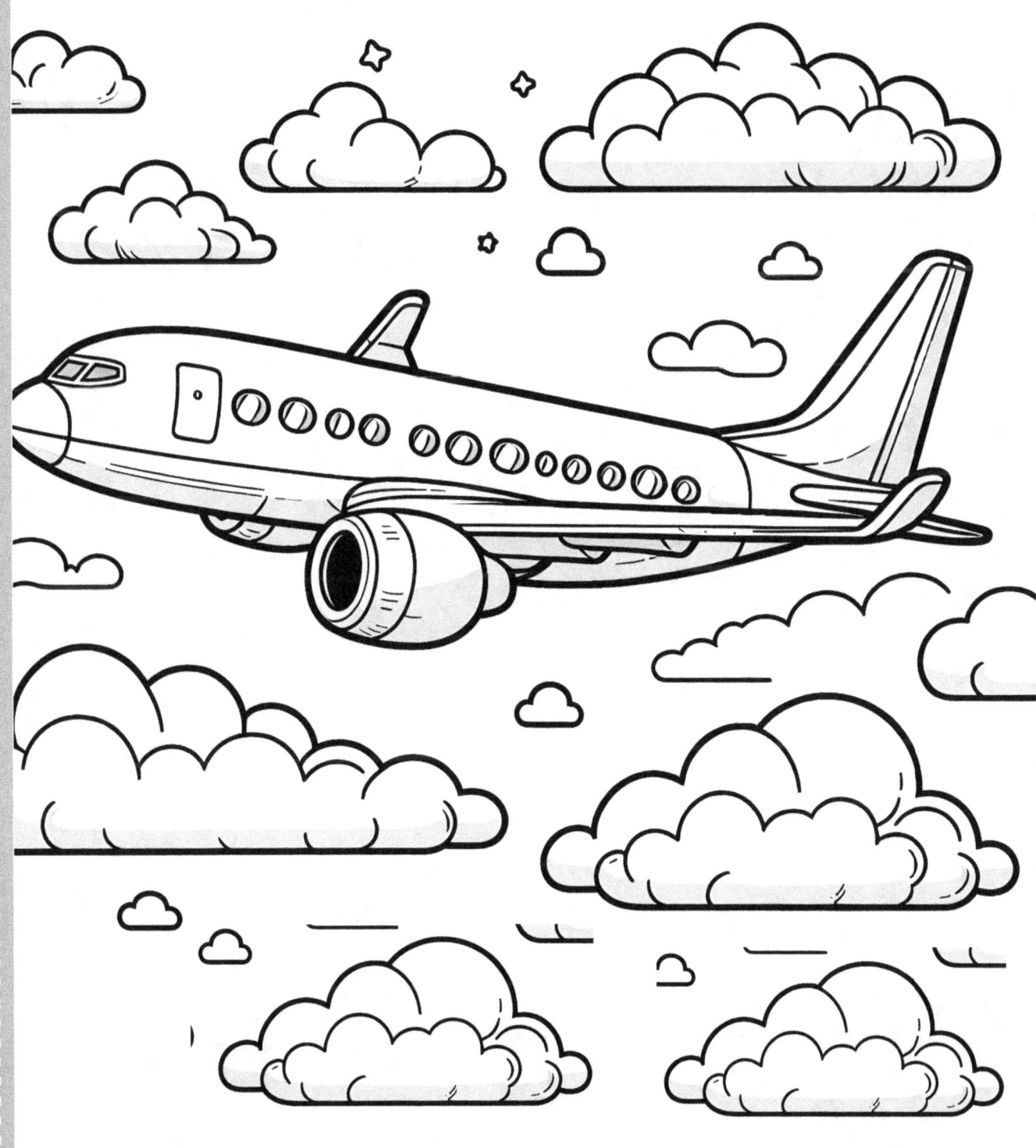

TRAM

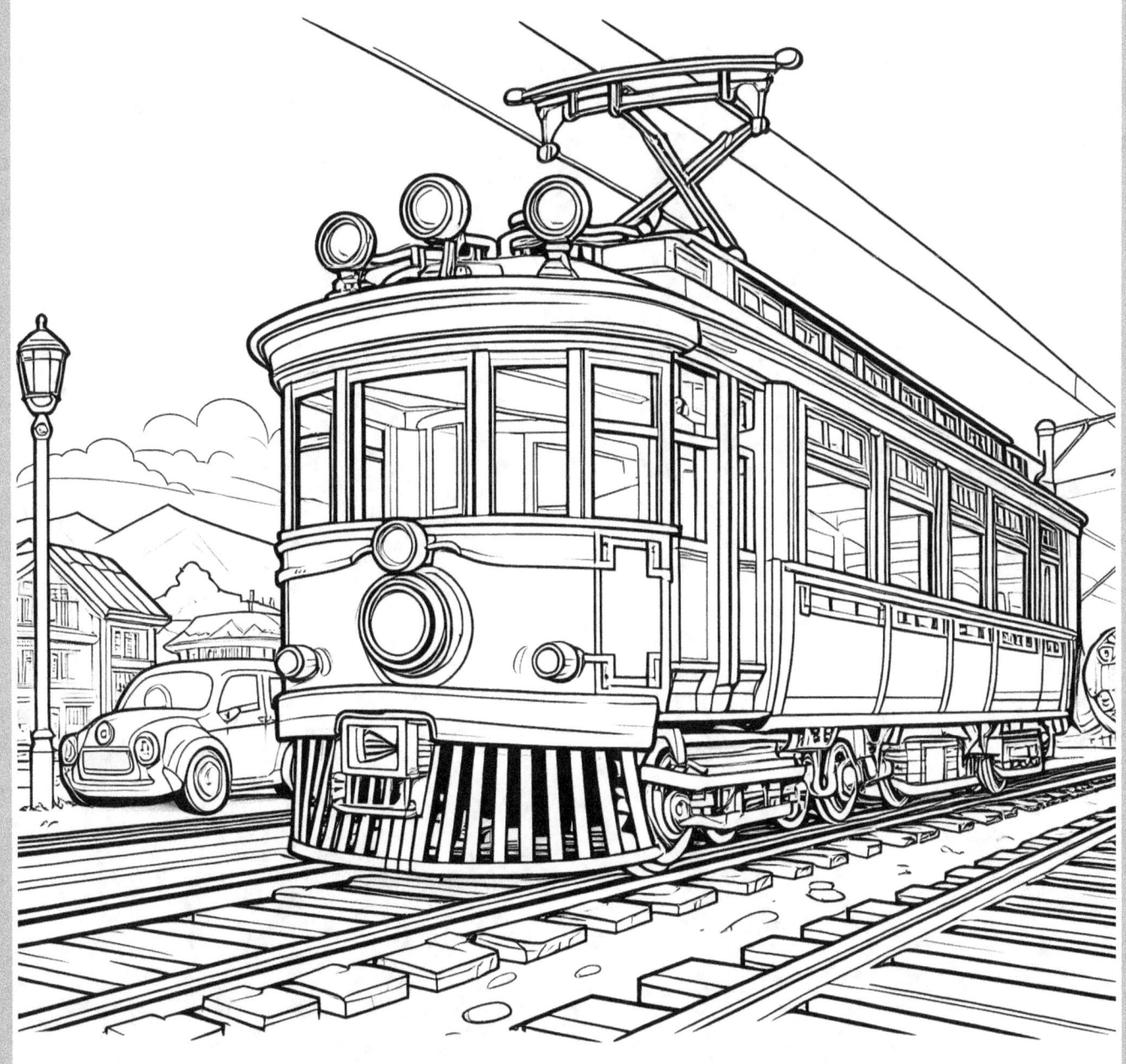

TRAIN

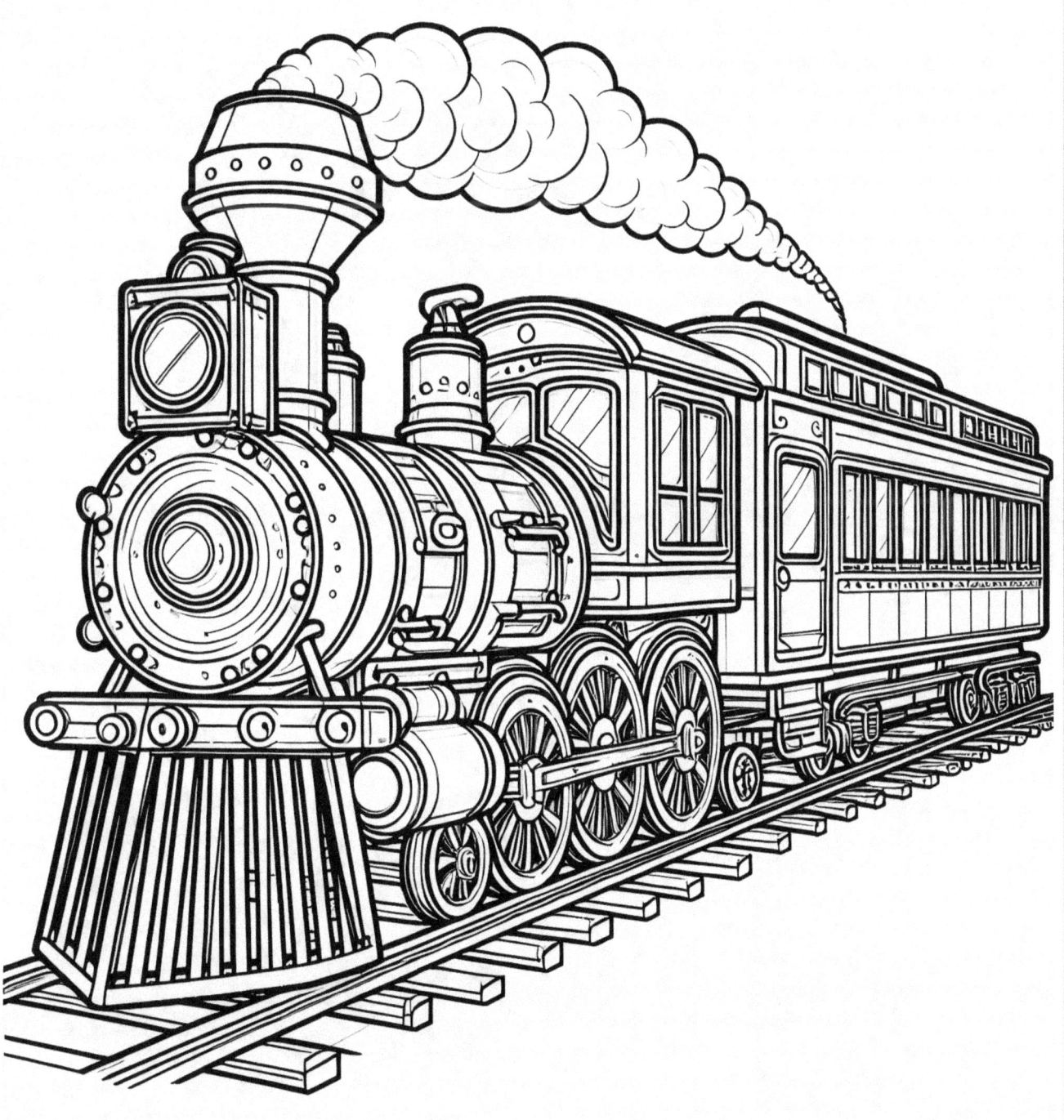

TAXI

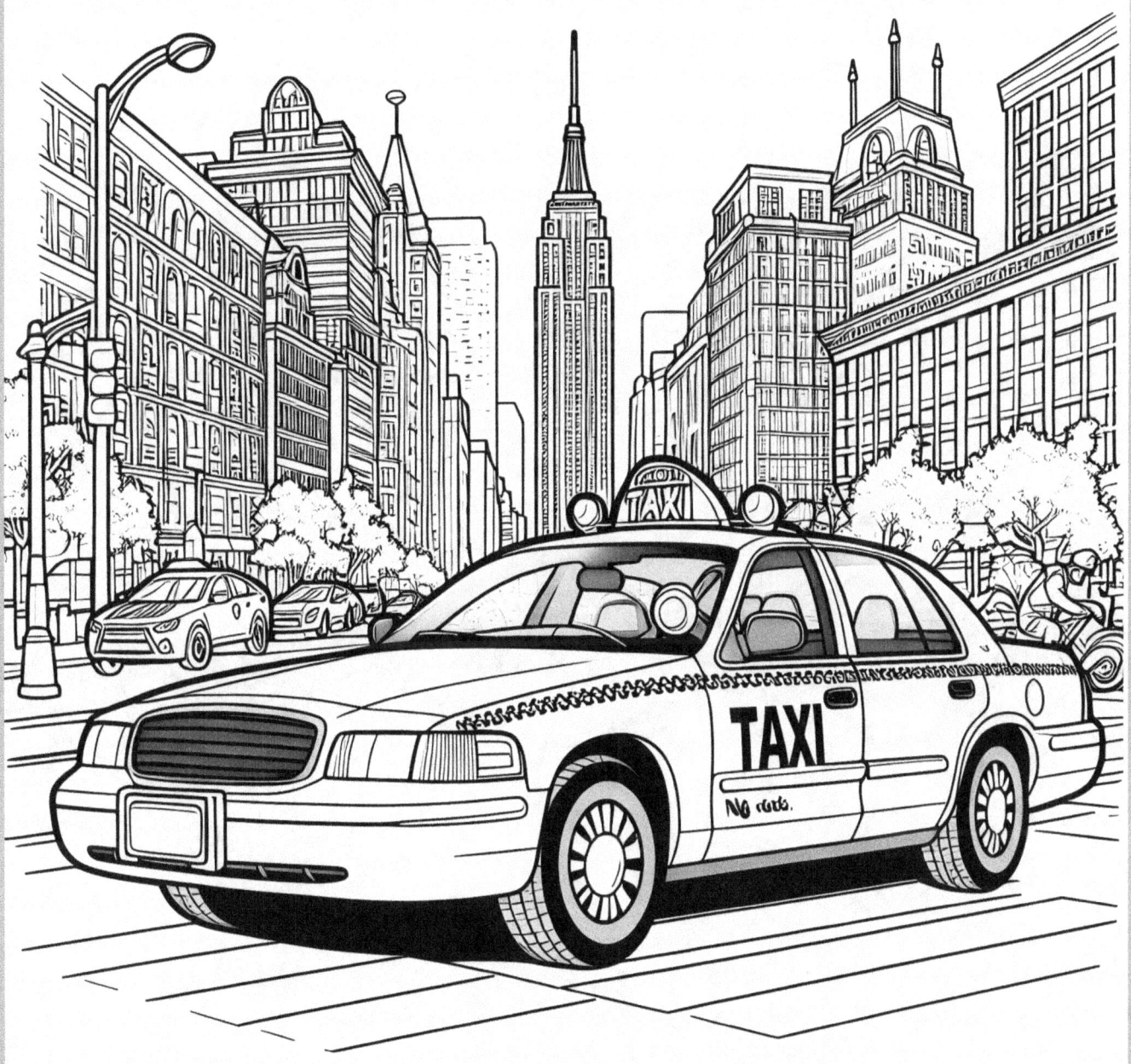

FIRE TRUCK

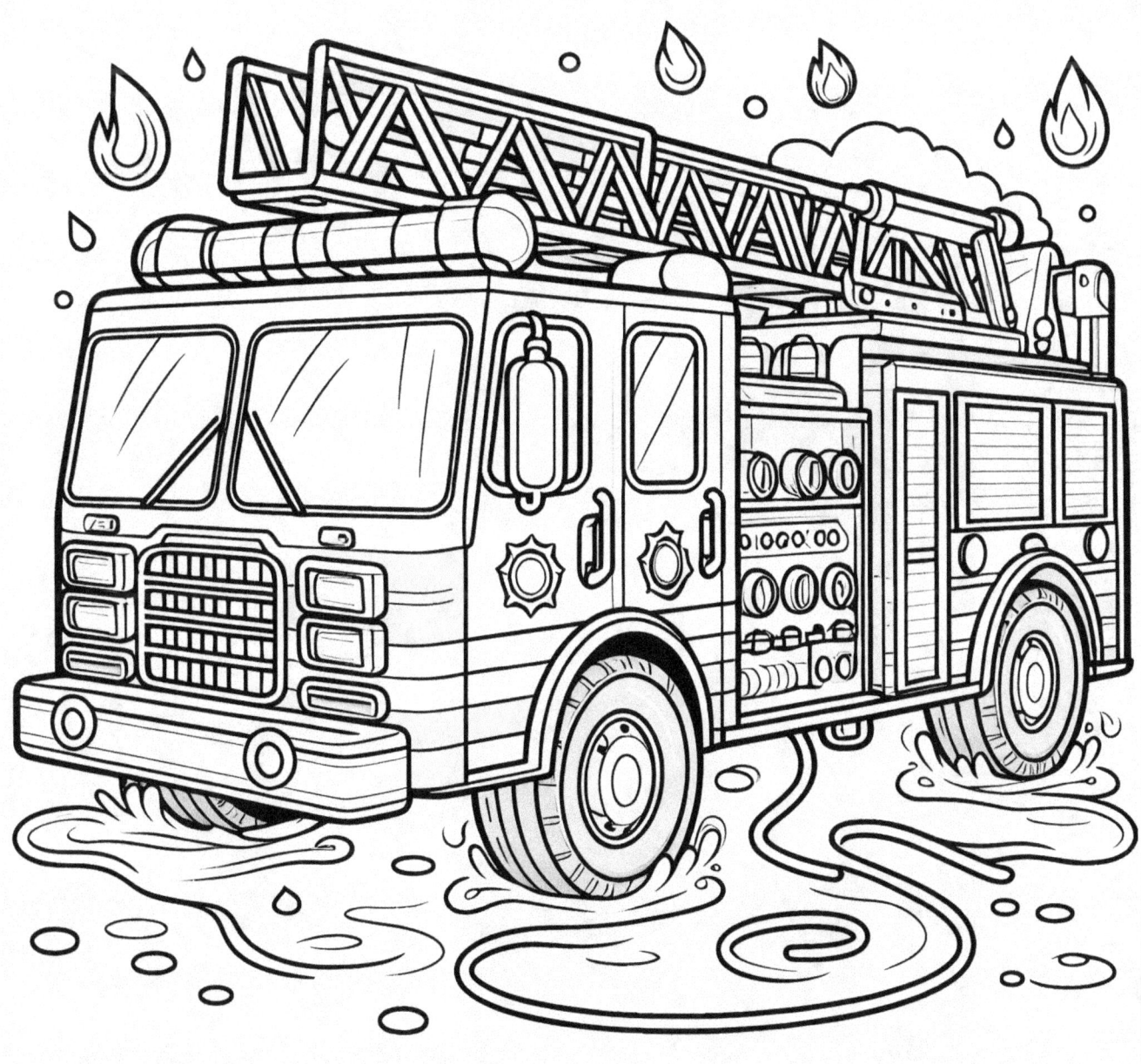

AMBULANCE

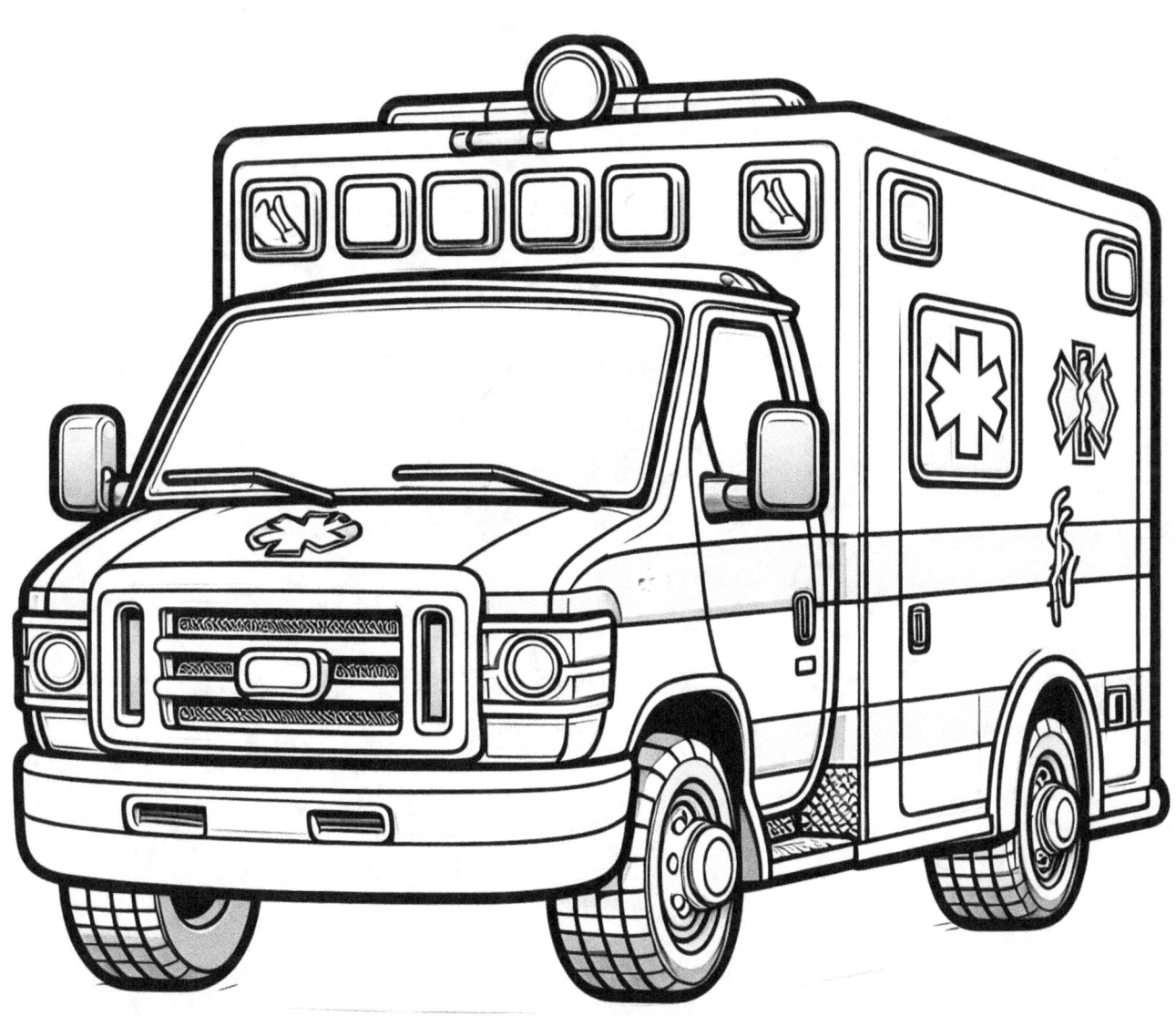

TRACTOR

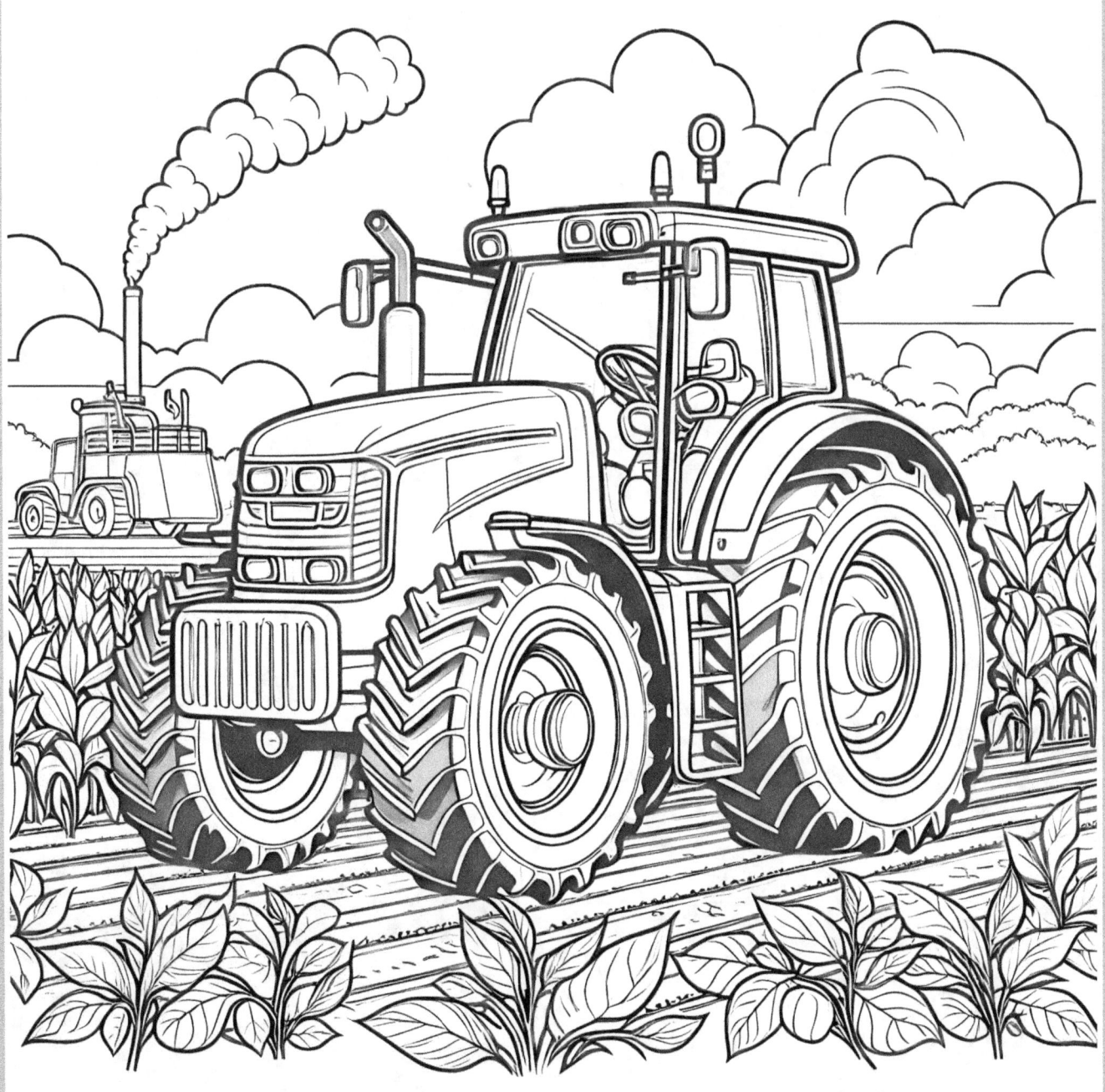

SCOOTER

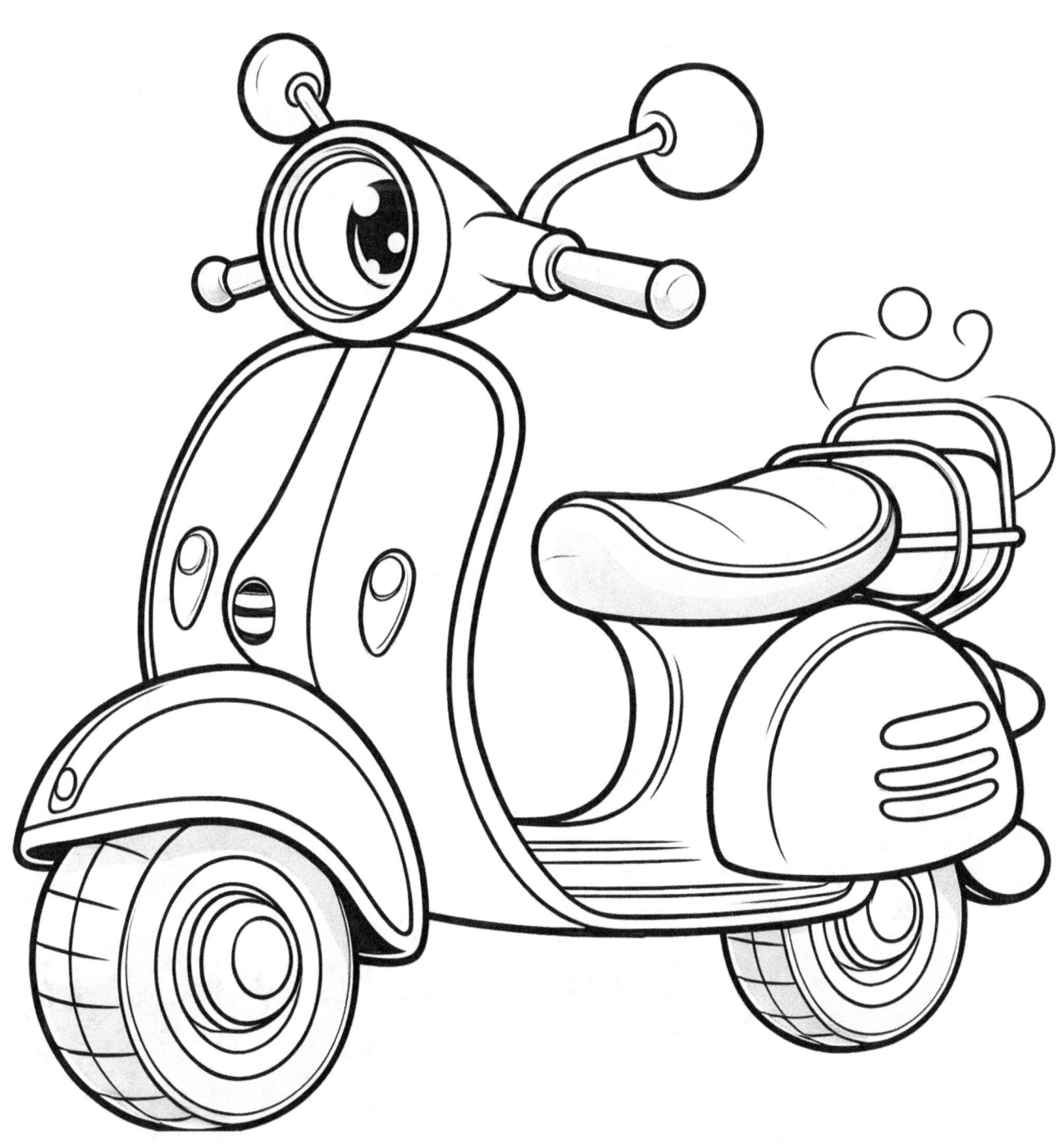

TRICYCLE

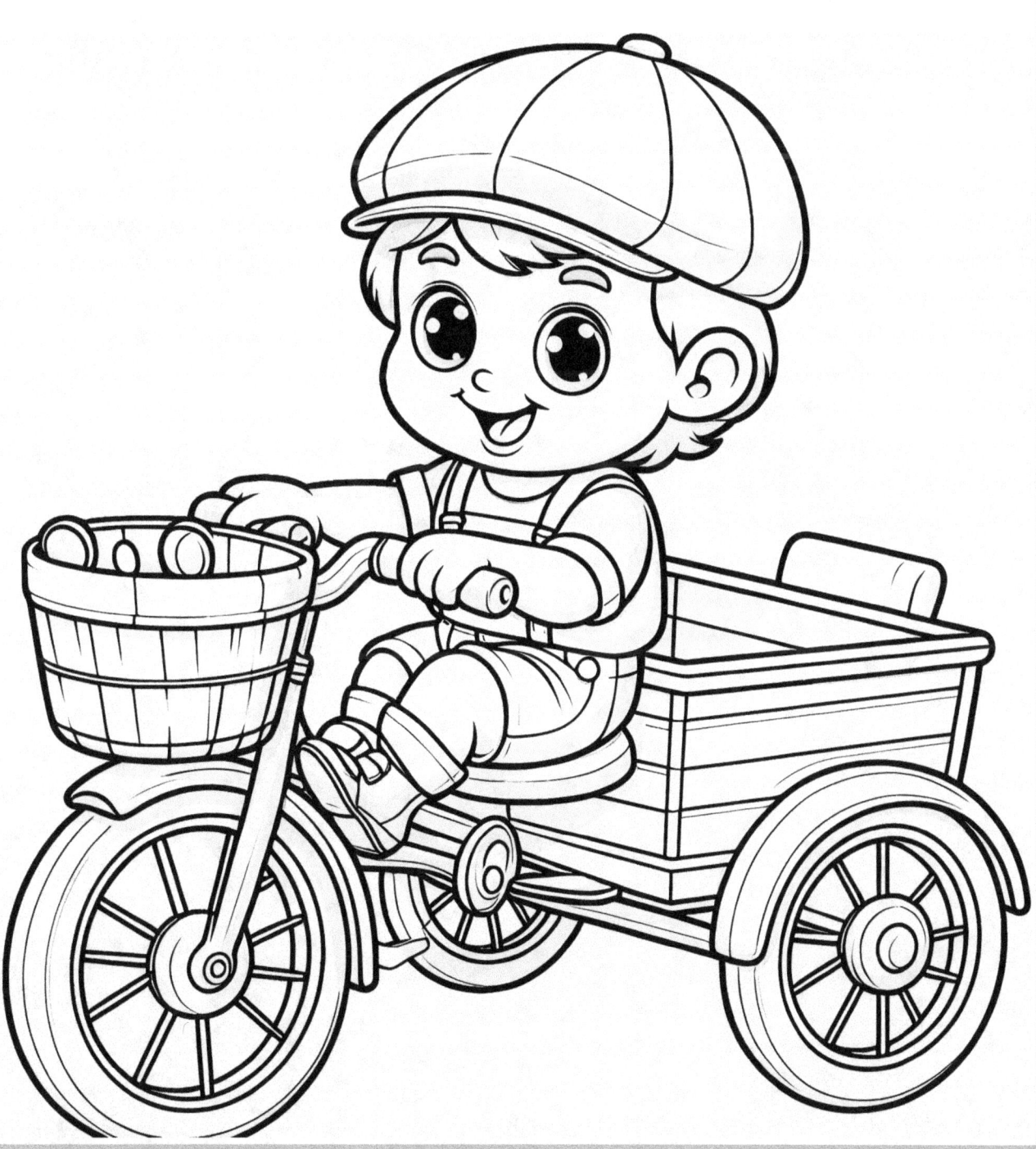

MOTORCYCLE

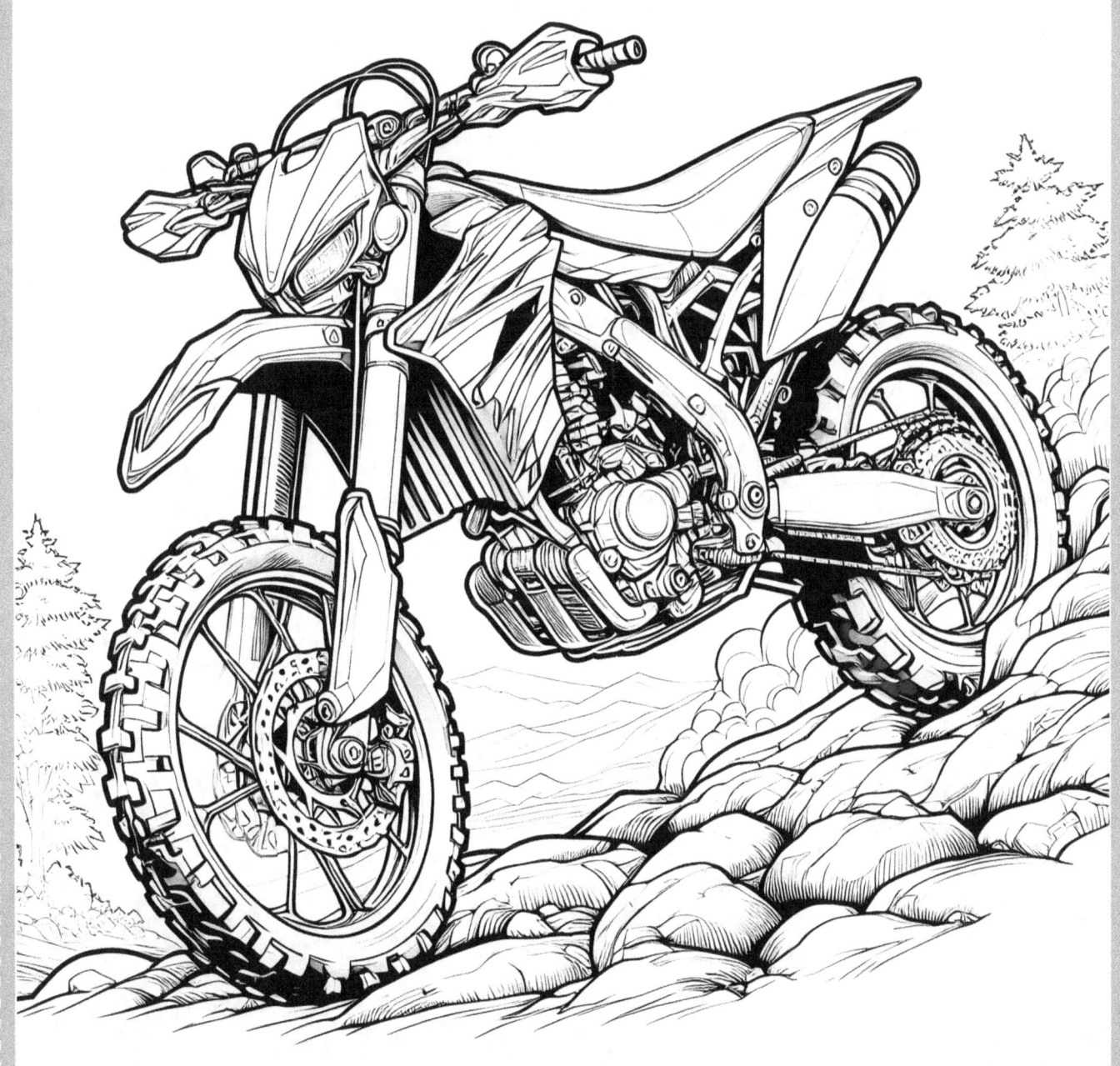

BICYCLE

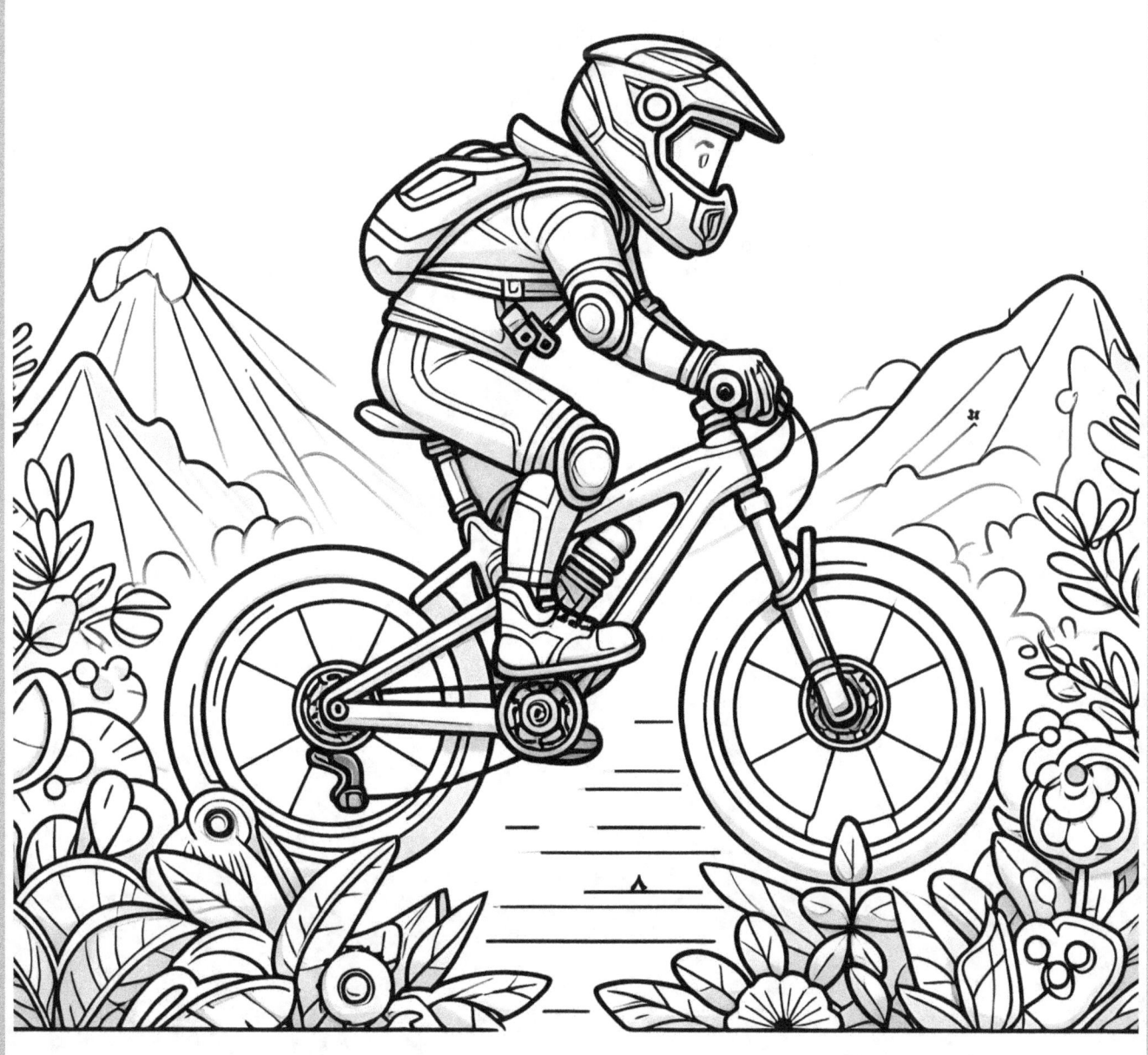

BUS

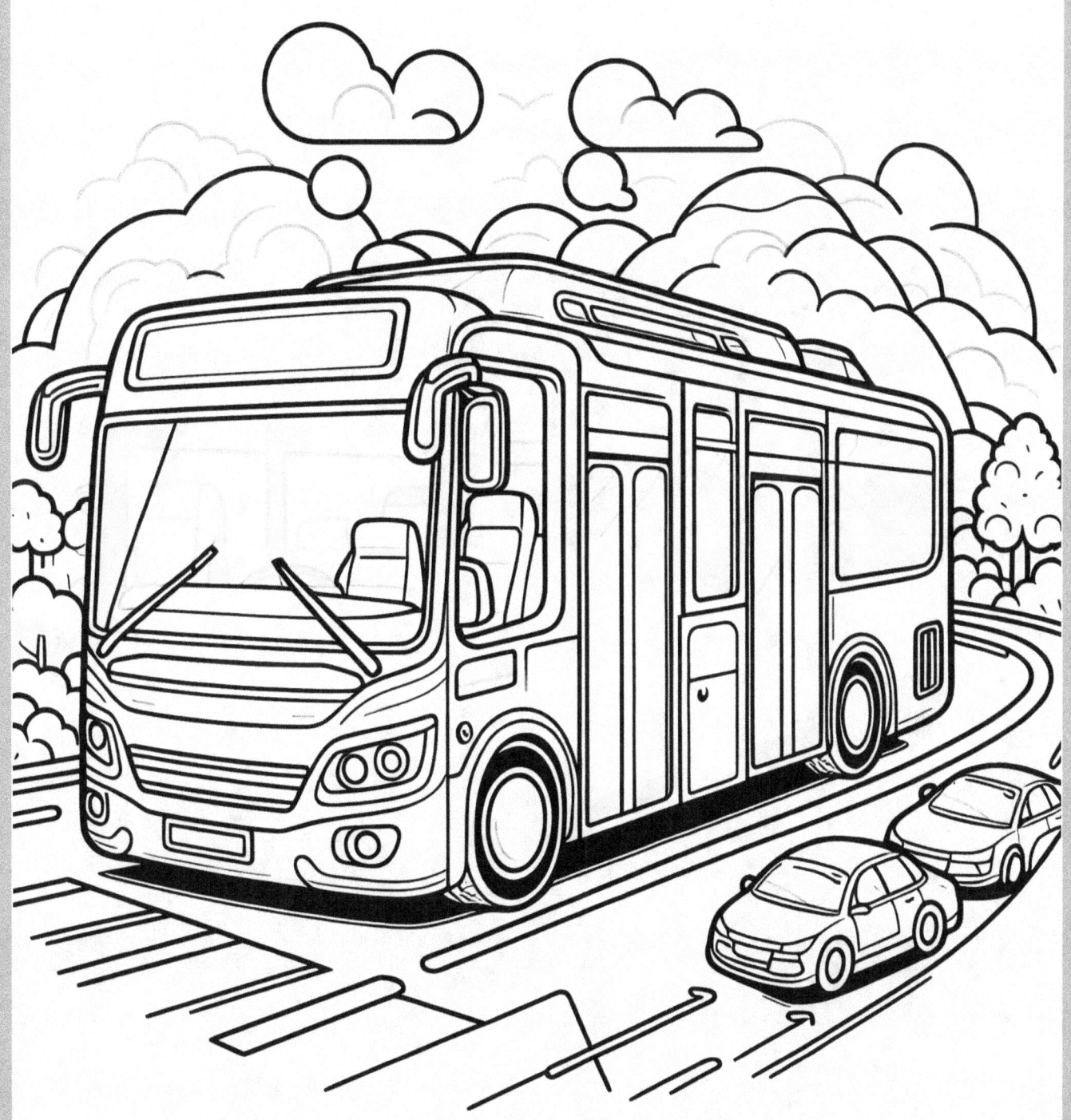

SUBMARINE

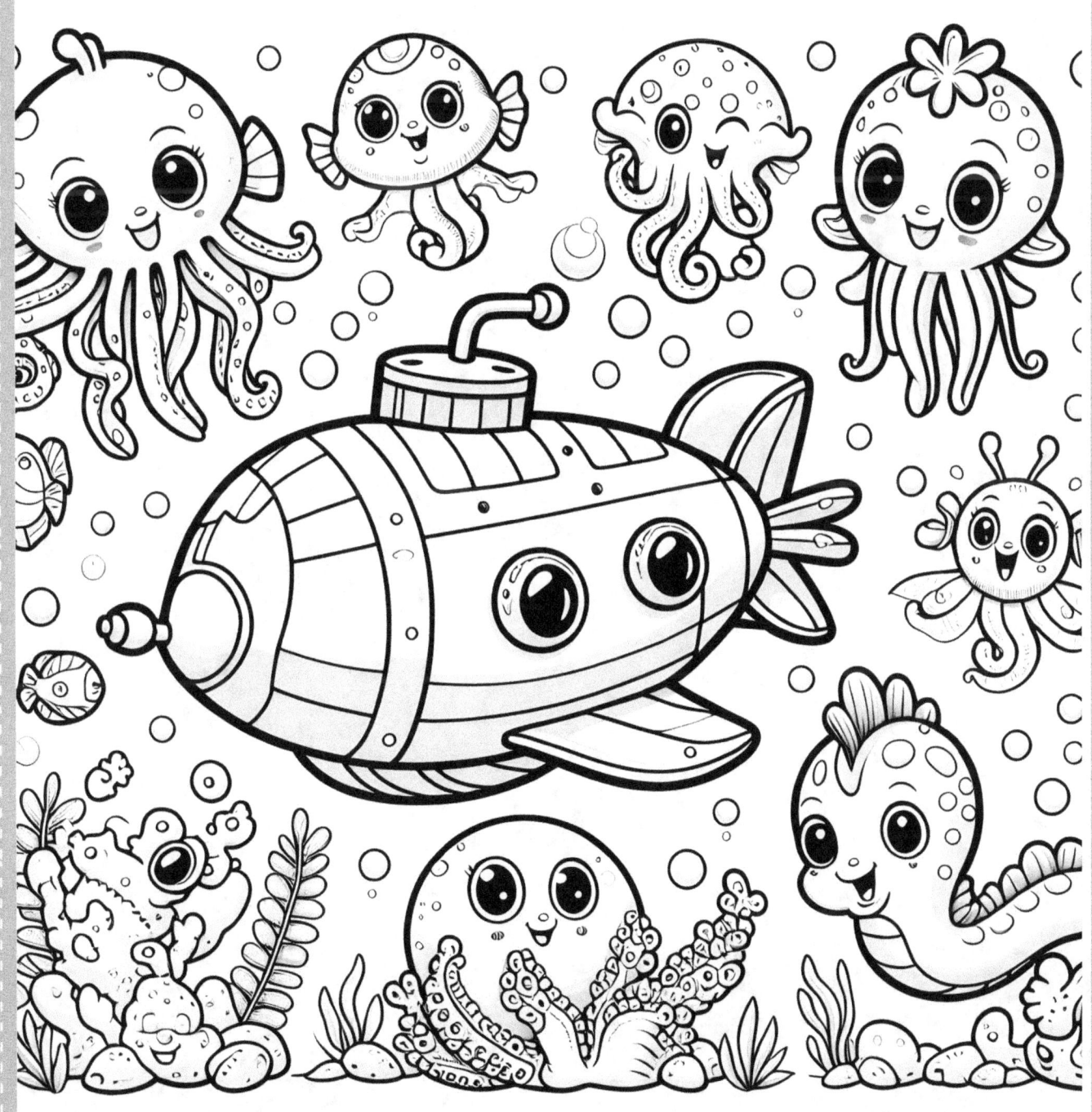

TRUCK

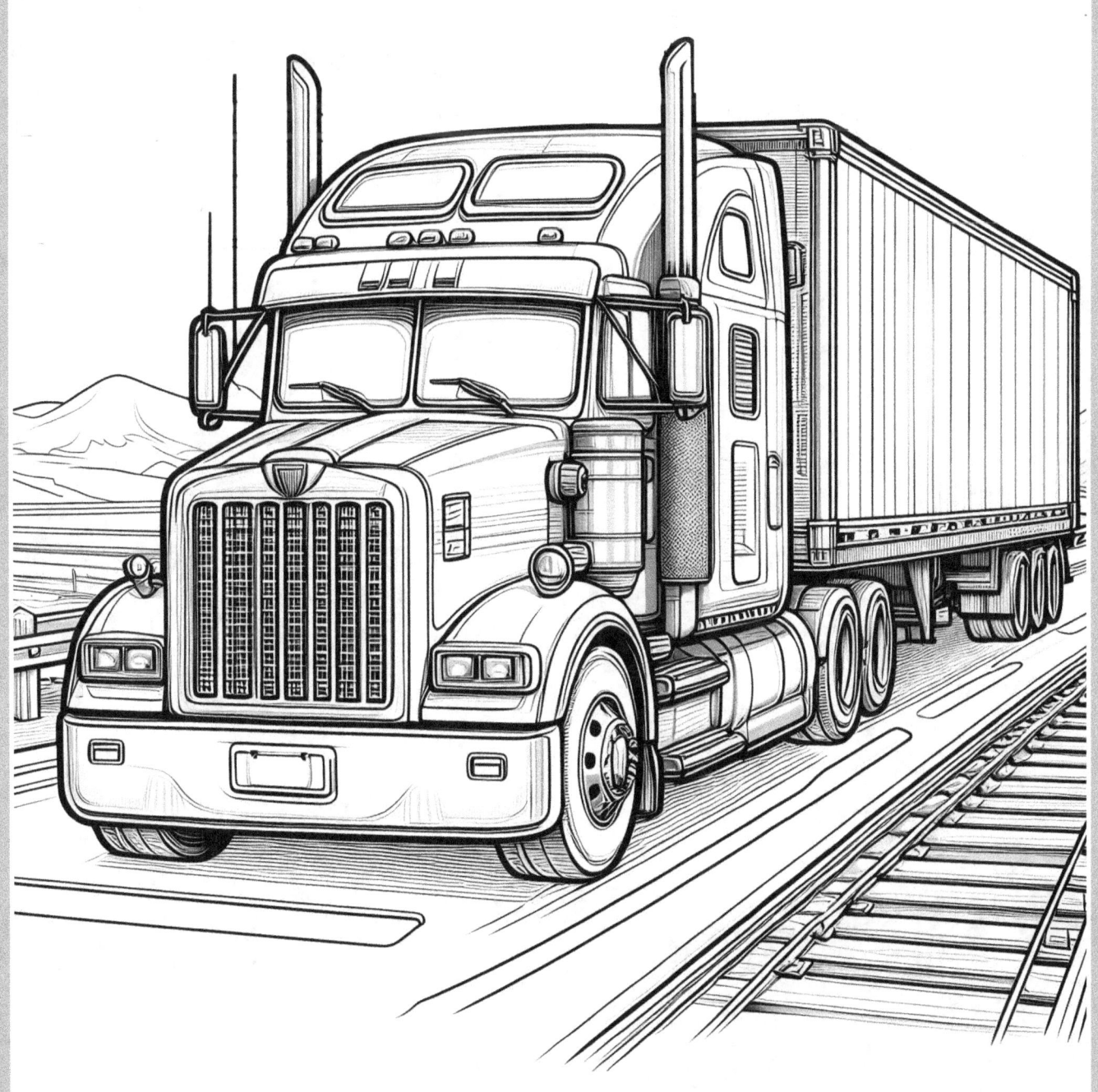

GARBAGE TRUCK

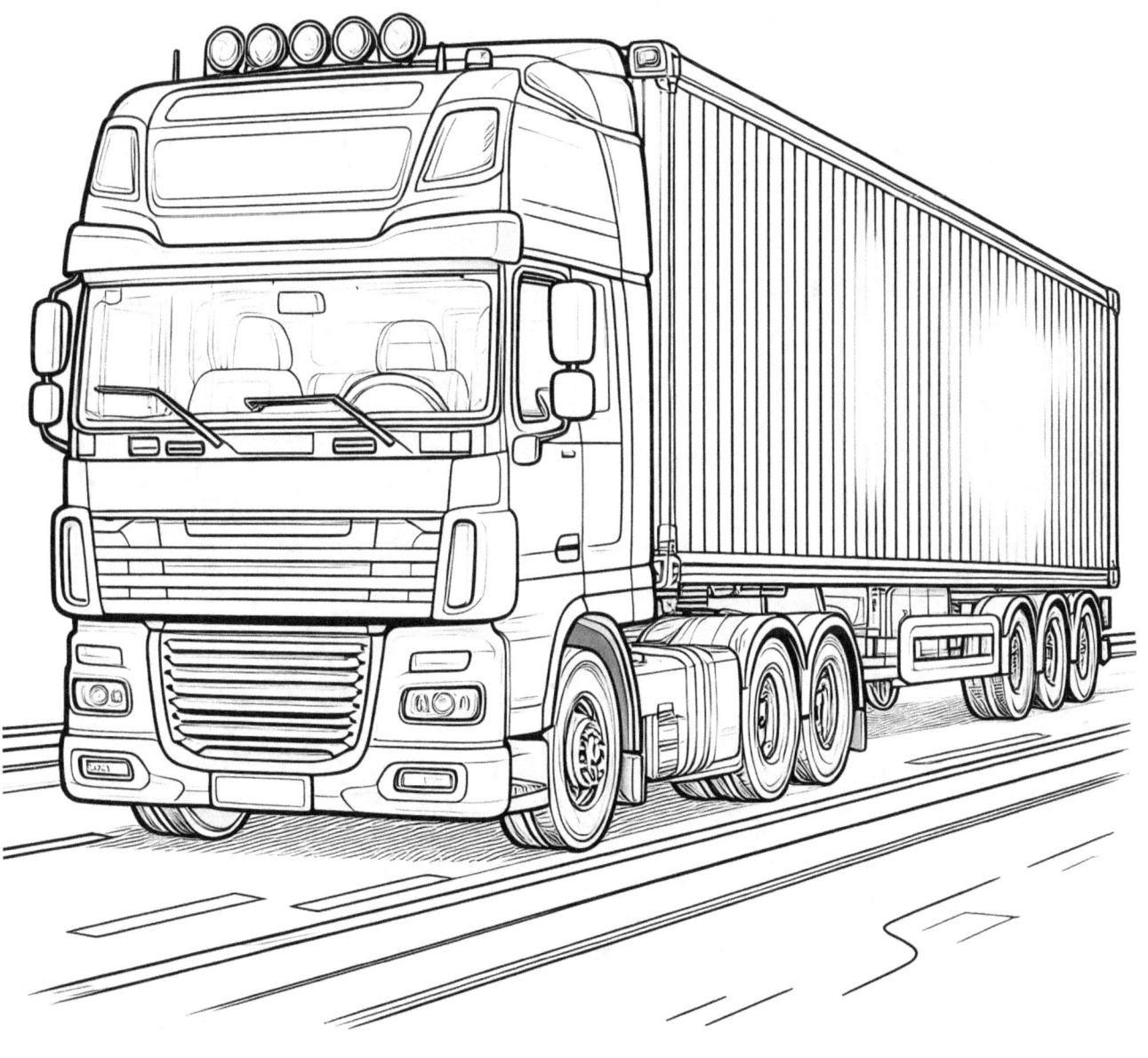

CAR

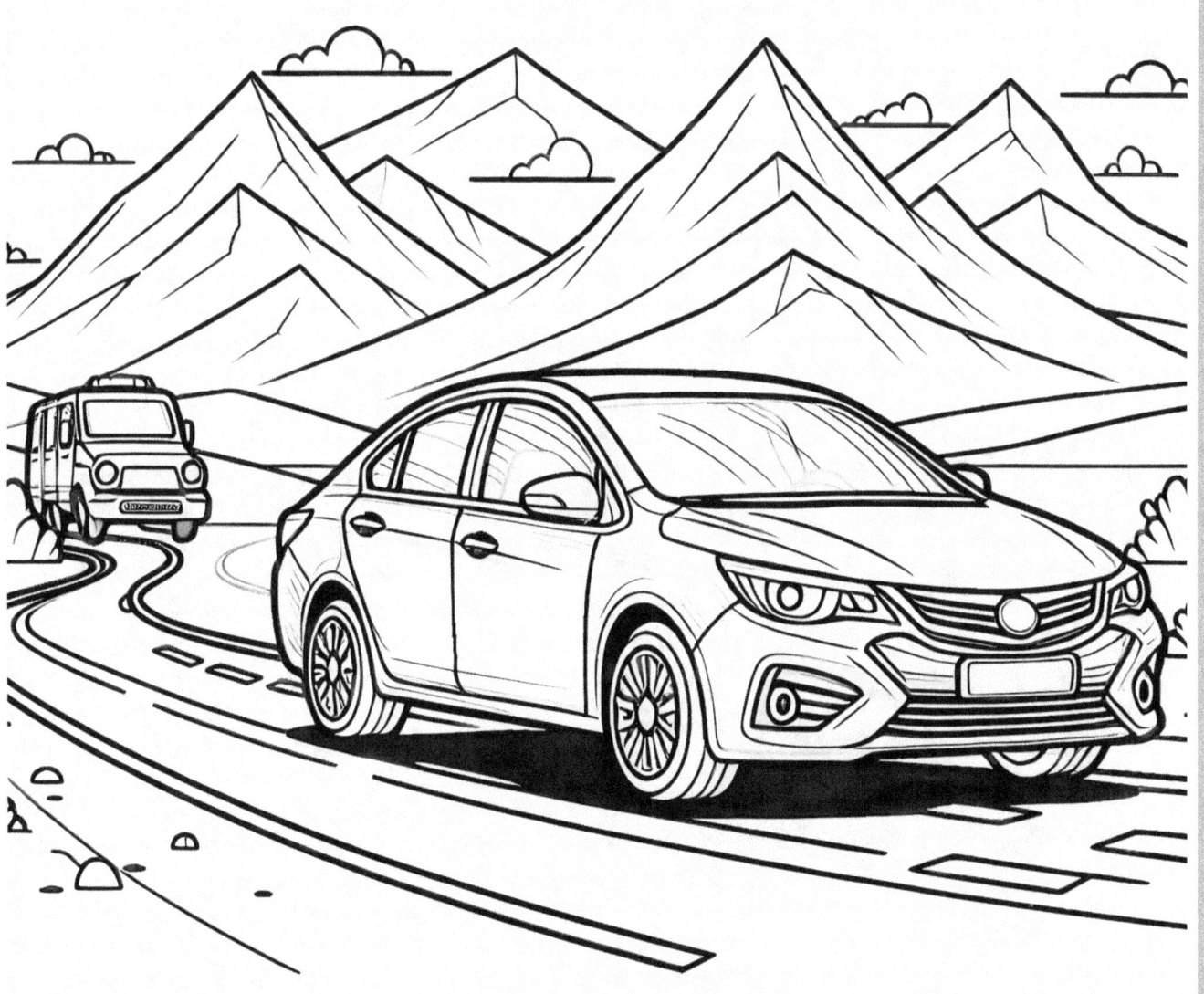

WAR TANK

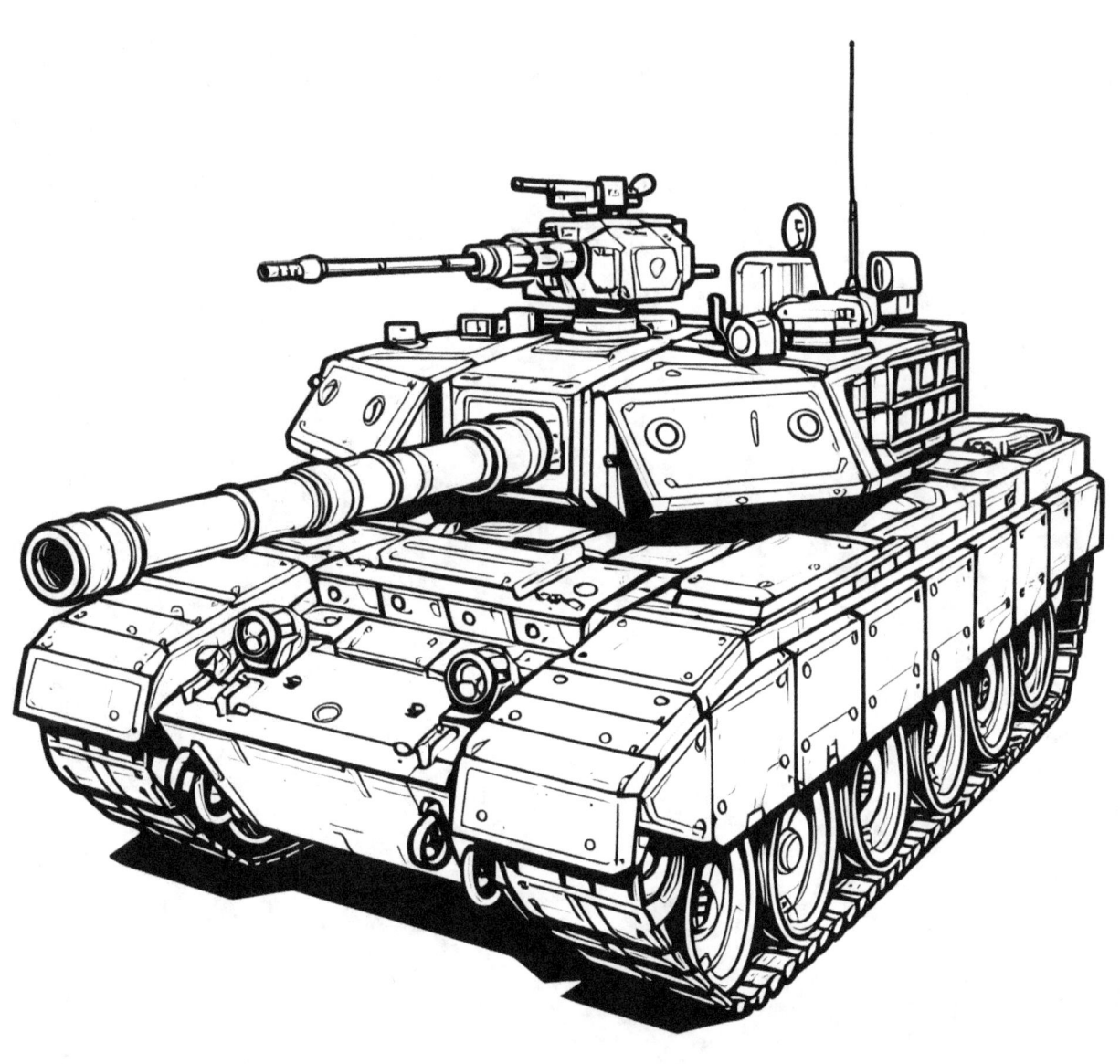

RACING MOTORCYCLE

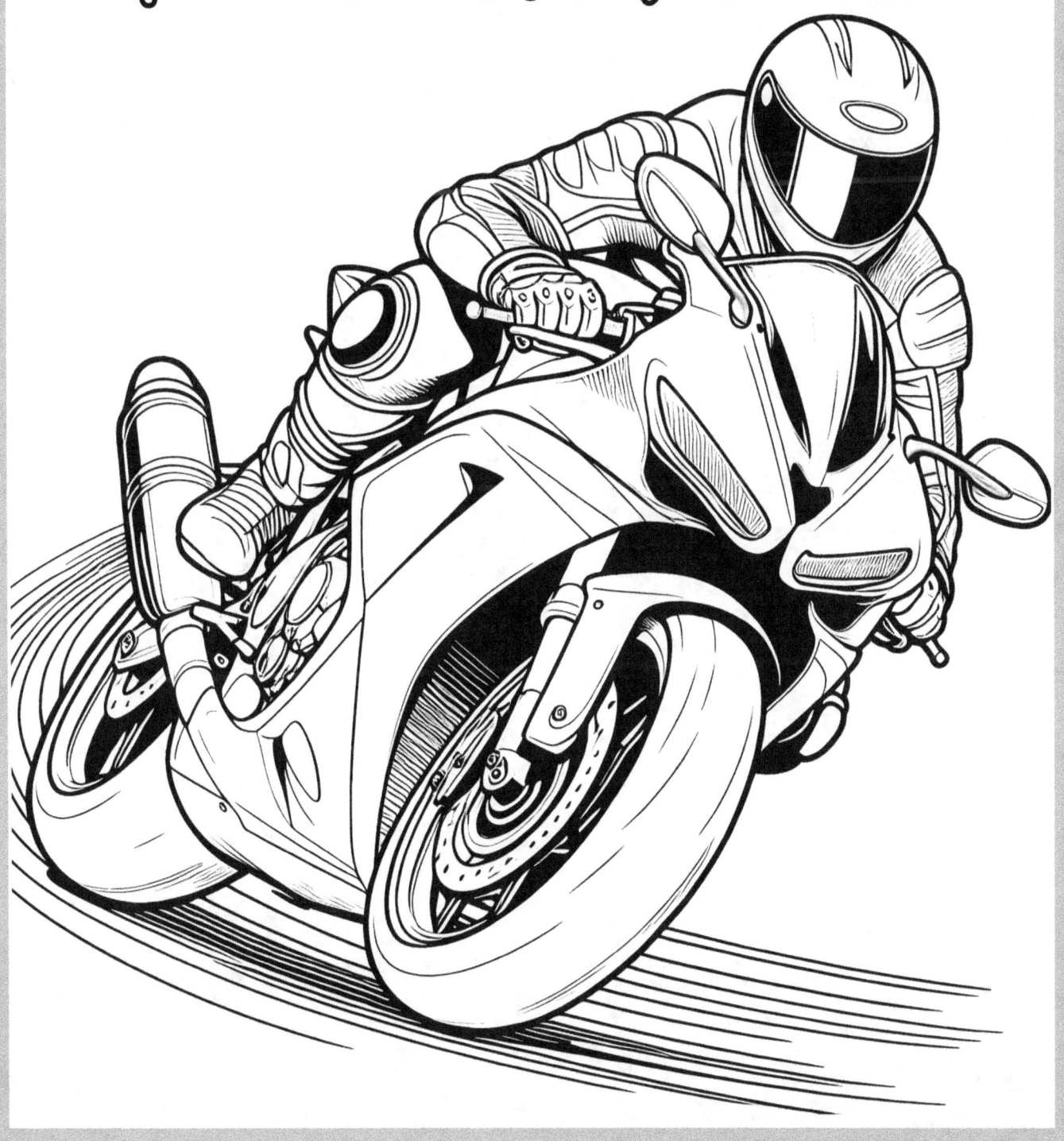

www.ingramcontent.com/pod-product-compliance
Lightning Source LLC
Chambersburg PA
CBHW082241220526

45479CB00005B/1300